SICILIAN

PASSAGE

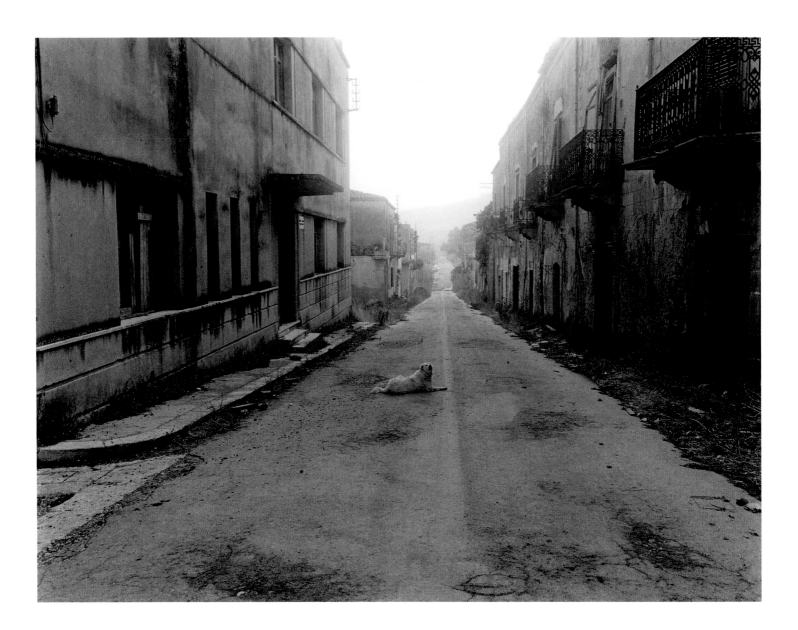

THOMAS ROMA

Sicilian Passage

INTRODUCTION BY SANDRA S. PHILLIPS

AFTERWORD BY ANNA ROMA

POWERHOUSE BOOKS · NEW YORK

TO MY MOTHER

SICILY has one of Europe's most distant pasts. Located at the center of the Mediterranean, its intense beauty is matched by its misfortune—invaded, occupied, or colonized not only by the Greeks and Romans, but by the Barbarians, Arabs, Normans, and Spanish as well. Yet no matter how distant it may be from us, physically and psychically, the island consistently evokes myriad images, many of them romantic: of antique monuments and whole towns of perfectly preserved baroque architecture; of its still-active volcano, Mount Etna, whose constant activity the ancients ascribed to the restlessness of a giant who slept beneath the earth; and, of course, of the Mafia. It would be easy to see the land sentimentally, as a spectacle: to see it as different from what we know.

Thomas Roma lives in Brooklyn, and his heritage is Sicilian. From 1982 to 1991 he visited this island often and knows it well. His pictures of Sicily are as natural and intimate as snapshots; they lack the rhetoric of exotic places. In fact, the photographs here are about making connections, seeing resemblances rather than finding differences. There is the ease of the familiar in the way Roma approaches his subject. We sense that the old man and the boy sitting under the olive tree speckled by light and the calm, fierce woman leaning against a shady wall have all been talking with him. They could be easily the Brooklynites he sees each day in his own neighborhood, and it is likely the same conversation.

There is something both ancient and modern in what he finds, both familiar and new. There are no shepherds in Brooklyn, yet the young Sicilian man shirtless and in blue jeans who leans against the serpentine form of a tree, or another holding his shepherd's staff and squinting into the sun, are related to the young men of Prospect Park on a hot summer's day, or to their cousins who can be found in front of their houses, working on a car. In Roma's Sicily, an automobile drives past a man on the road on horseback, trying to control his startled animal.

Although there are large cities on the island, the Sicily pictured here is rural, but inhabited—transformed by the people who live there. A pastoral field with blossoming wildflowers reveals in the distance a flock of grazing sheep. While Roma often focuses on disorder—corners of stacked tires, piles of lumber or sand, flying laundry, castoff bedsprings—his frame imposes a gentle, inclusive, and elegant order, where surprises can occur, like a little patch of basil growing vigorously in the hard soil, or a chicken enjoying the sun in some jerrybuilt cage.

Like the Sicilians themselves, Roma acknowledges the island's long history as well as the need to live in its present. There is a picture of massive limestone blocks, jumbled as though scattered in a quarry, and, barely visible, a beautifully-crafted, ancient stone wall with its archway filled in. The result of an earthquake? Of ancient looting? Of an old family's changed circumstances? In another there are the still-standing walls of a villa fallen to ruin; much of its structure is concealed by vegetation growing inside and given dimension by the power lines on the faraway hills. What is really photographed is the continuity of it all, with no attempt to isolate, categorize, or prefer one moment, but to accept the whole history.

This does not mean that Roma is blind to the particular drama of life here, situations that could be described as the experience of being Sicilian and not American. A woman looks at two men on a wet road one hot summer day; her glance is received by one of them lighting his cigarette. This picture—the glances, the heat, the light clothing she wears that reveals her underclothing, the intensity of her glance, the shiny slick pavement between them, the distant hazy landscape, the plastic water bottle on the edge of the road—all this we identify as foreign, as central or southern European, perhaps even as Sicilian. Nowhere else could one find an ancient olive tree as Roma has, much pruned and sawn, giving live birth to a vibrant new tree within. It is almost an embodiment, though in time reversed, of the Greek legend where the nymph Daphne was turned into a tree by her father the river god Peneus as she struggled to escape the unwanted advances of a pursuer.

Sandra S. Phillips · San Francisco

Mirror

And see on the trunk,
buds erupt:
a newer green than the grass
that quiets the heart;
the trunk seemed already dead,
bent over dead water.

And it all tastes of miracle to me.
I'm the cloud-water reflecting back
its piece of sky today
still bluer in the ditches,
the green exploding the bark
that wasn't there last night.

— Salvatore Quasimodo

Translated from the Italian
by Jonathan Galassi

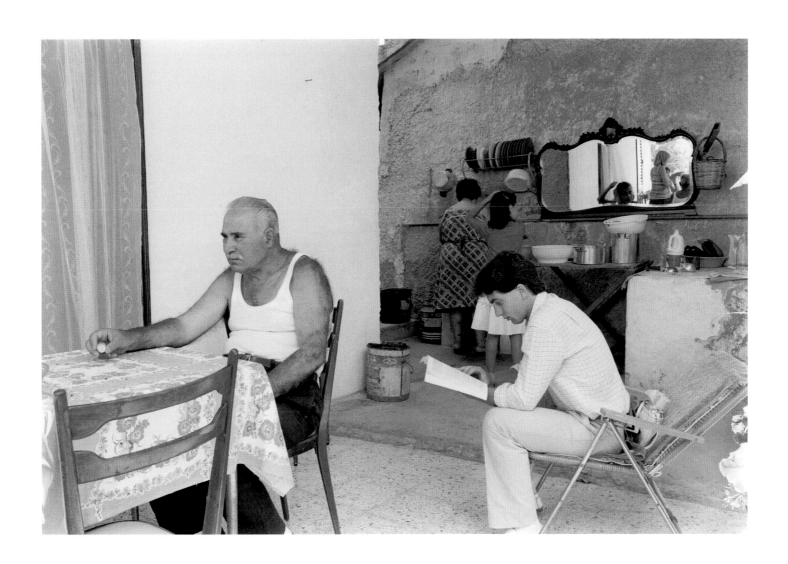

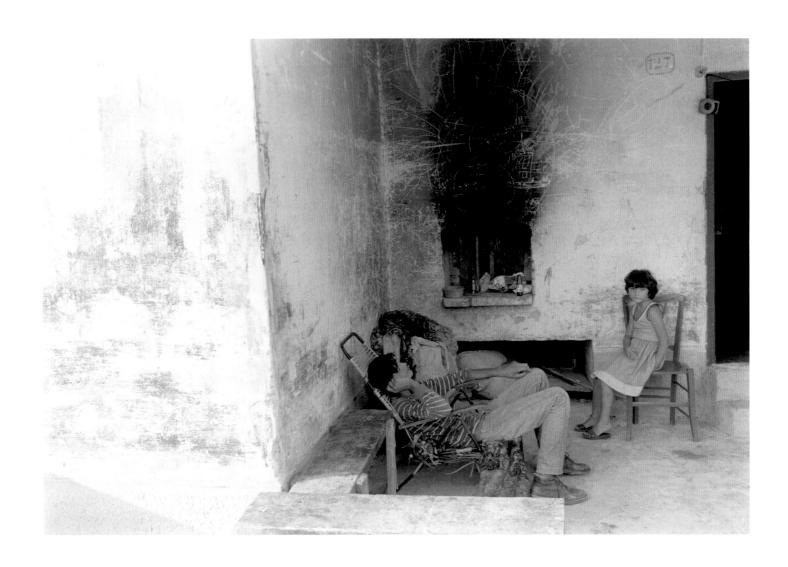

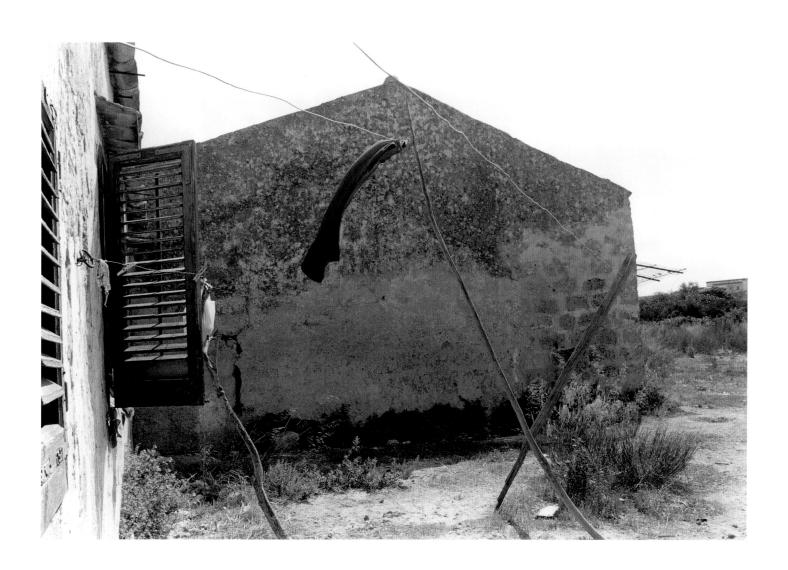

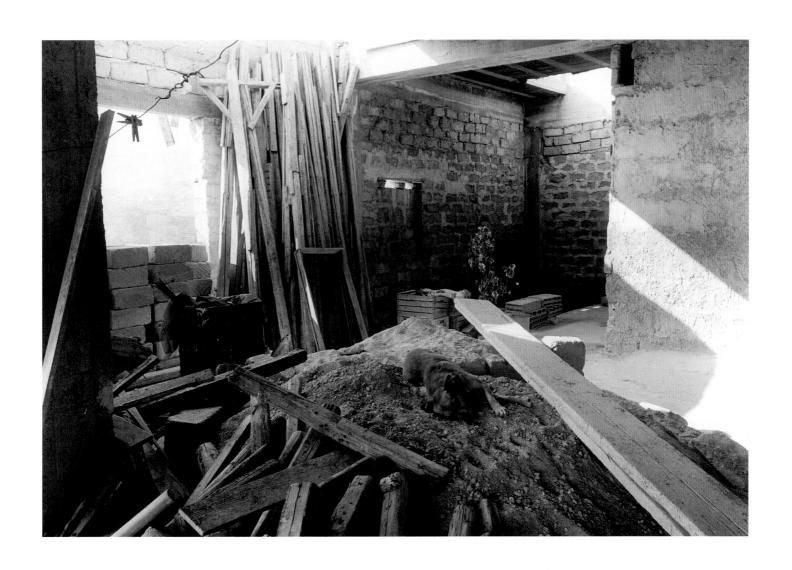

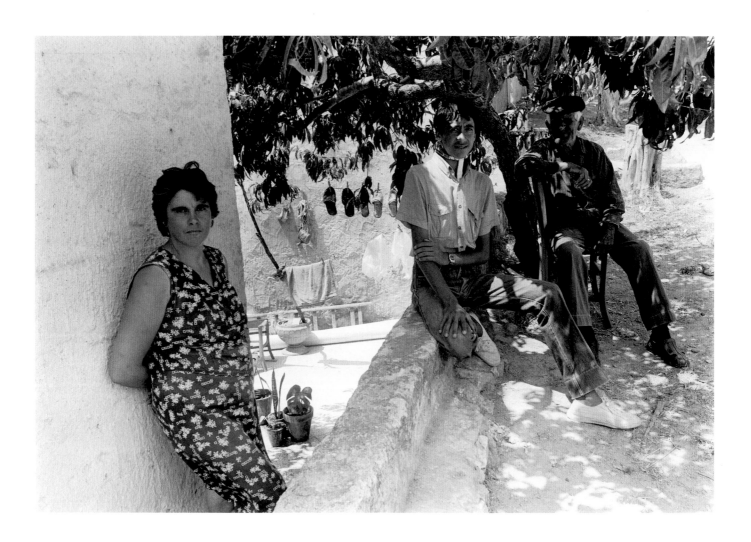

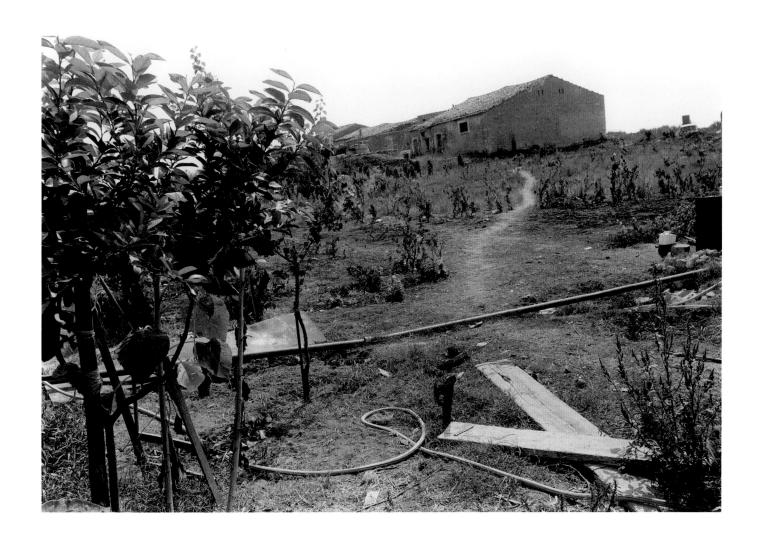

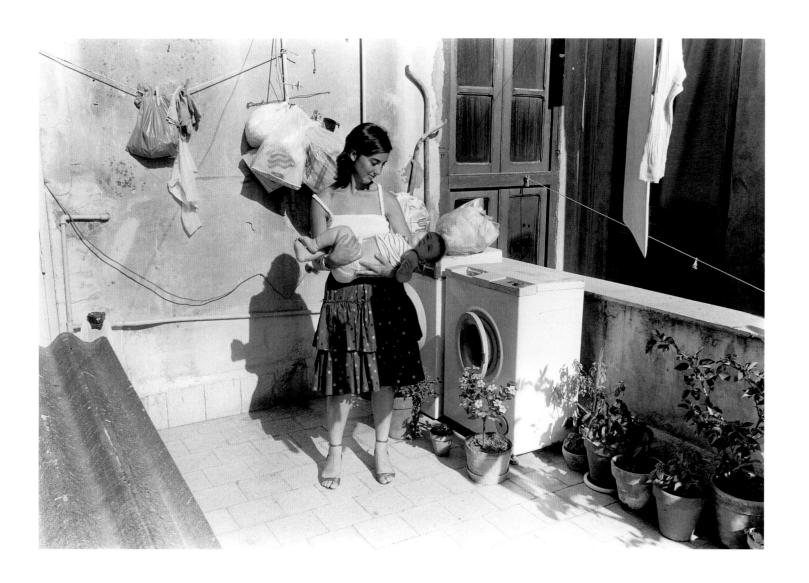

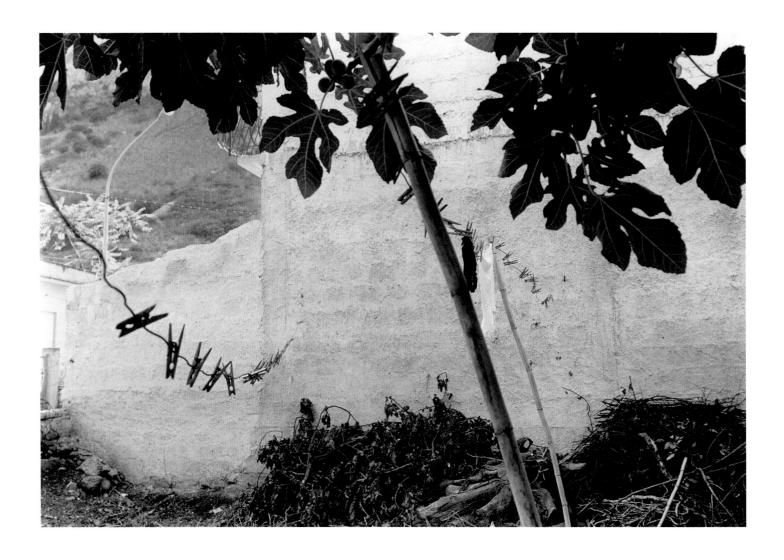

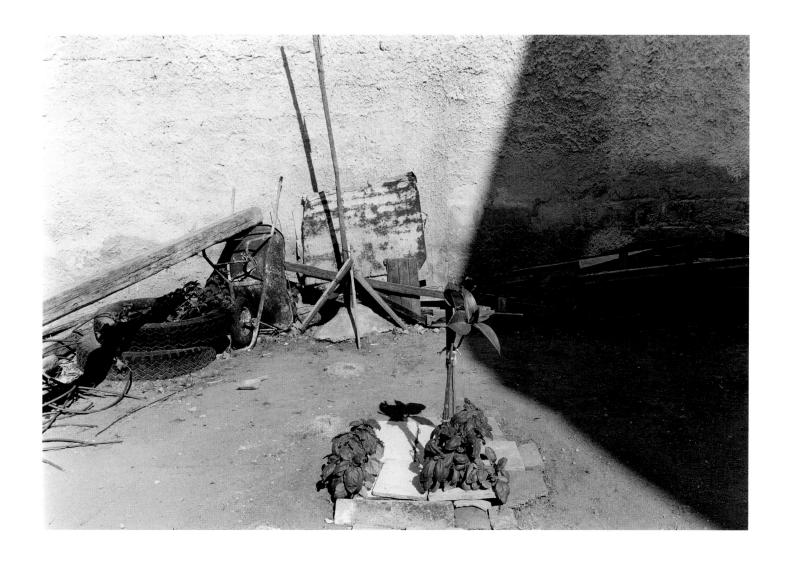

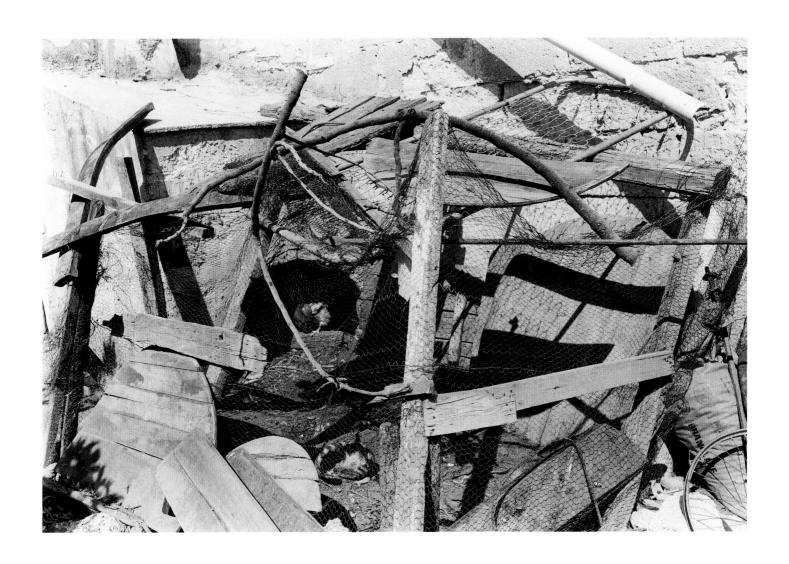

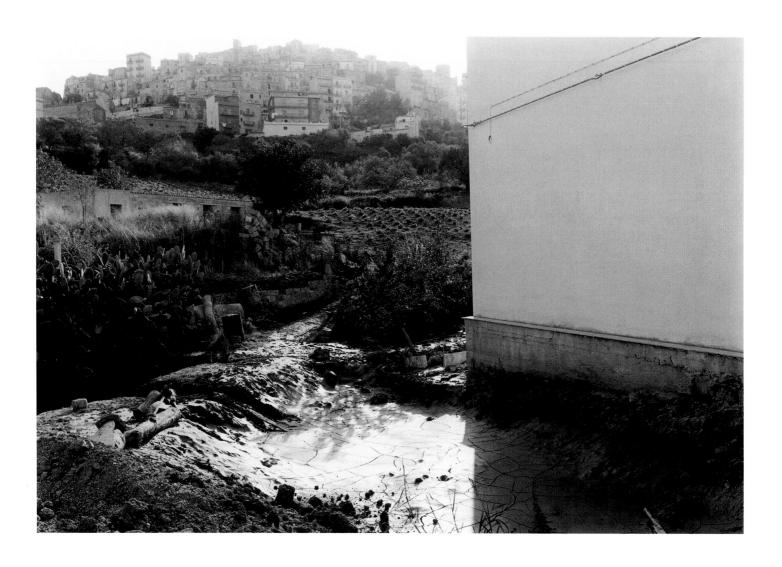

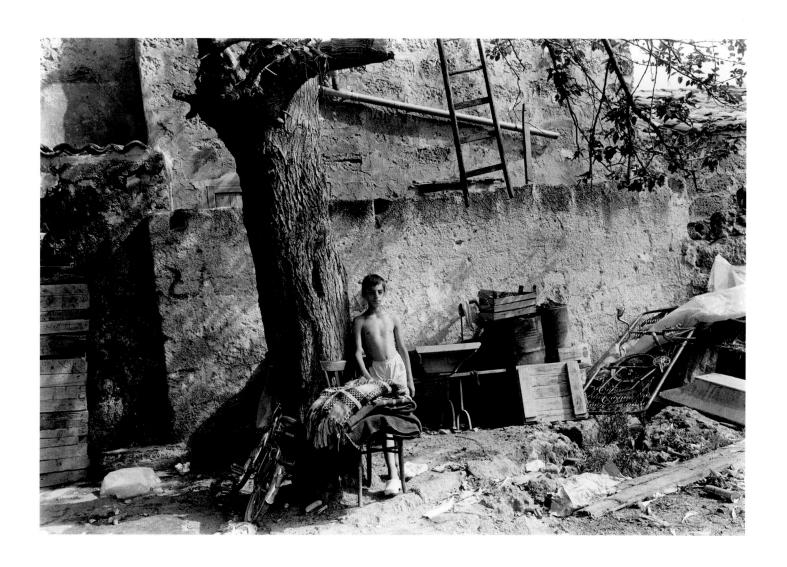

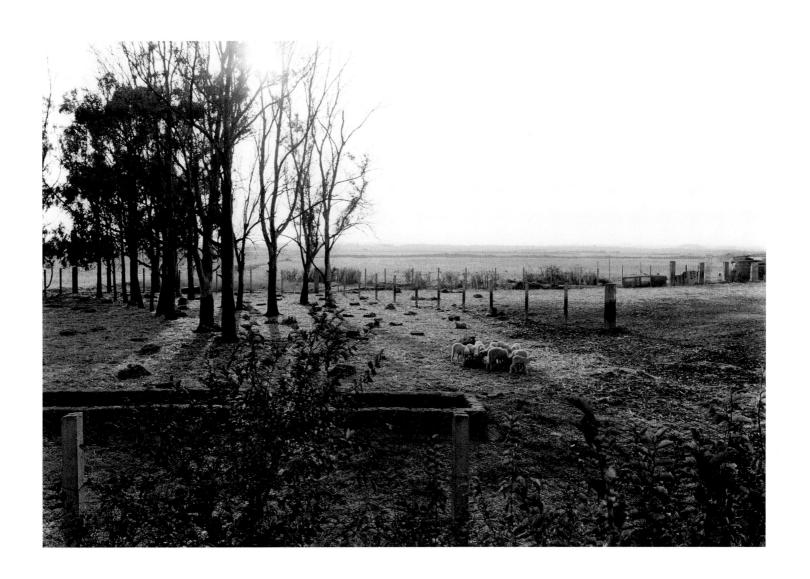

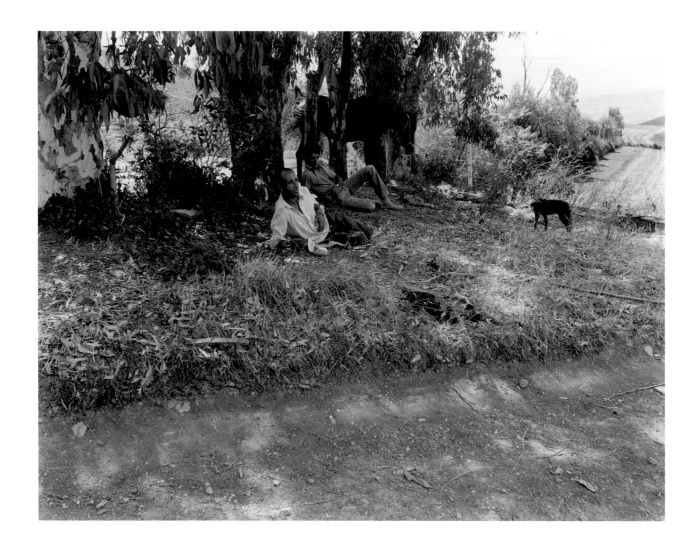

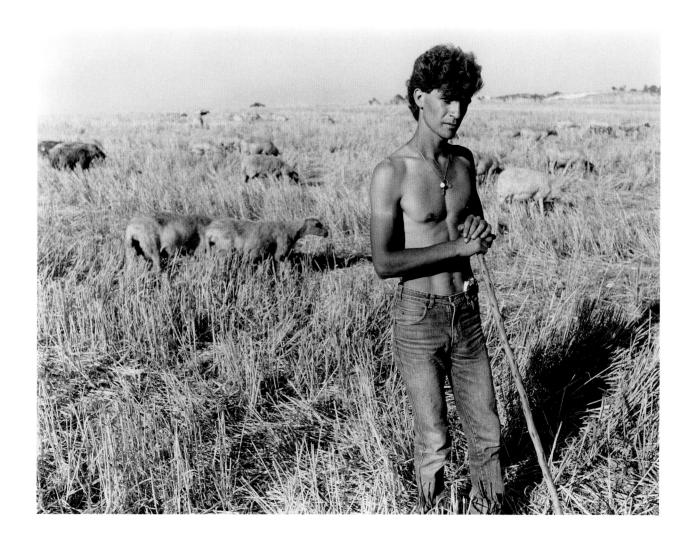

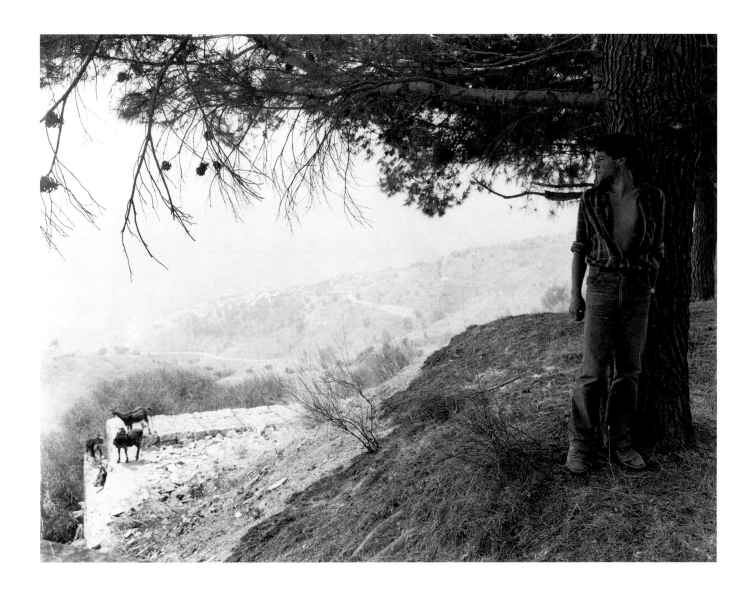

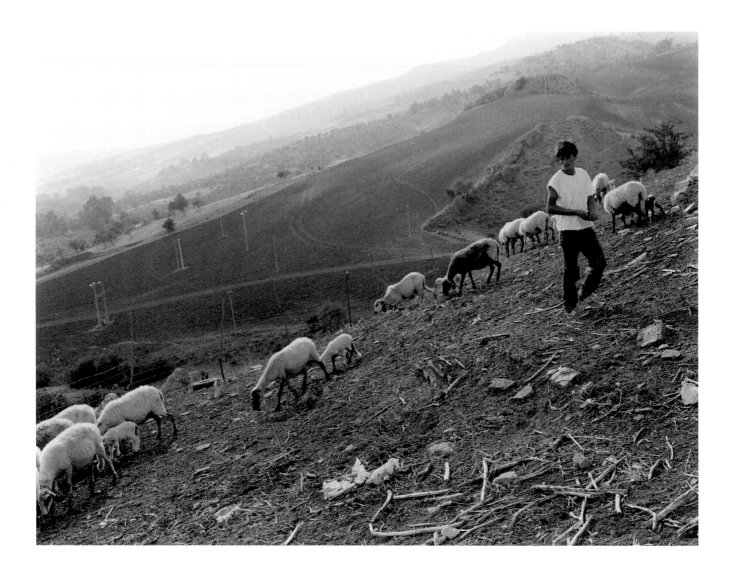

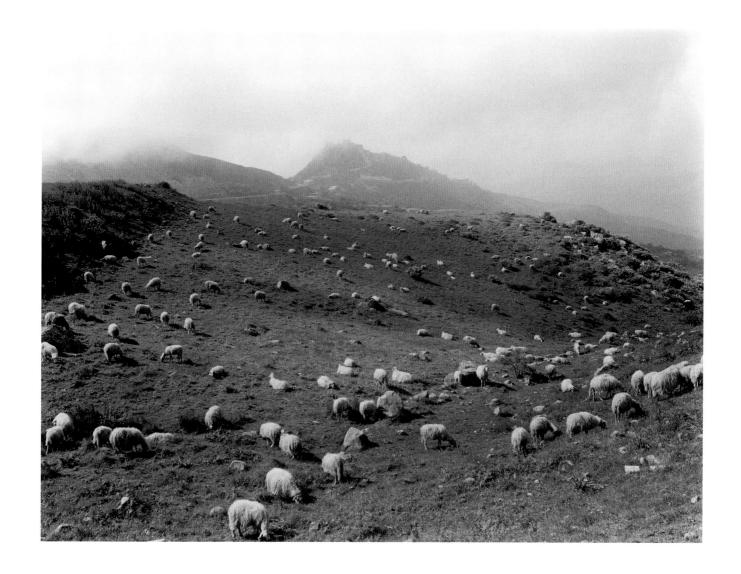

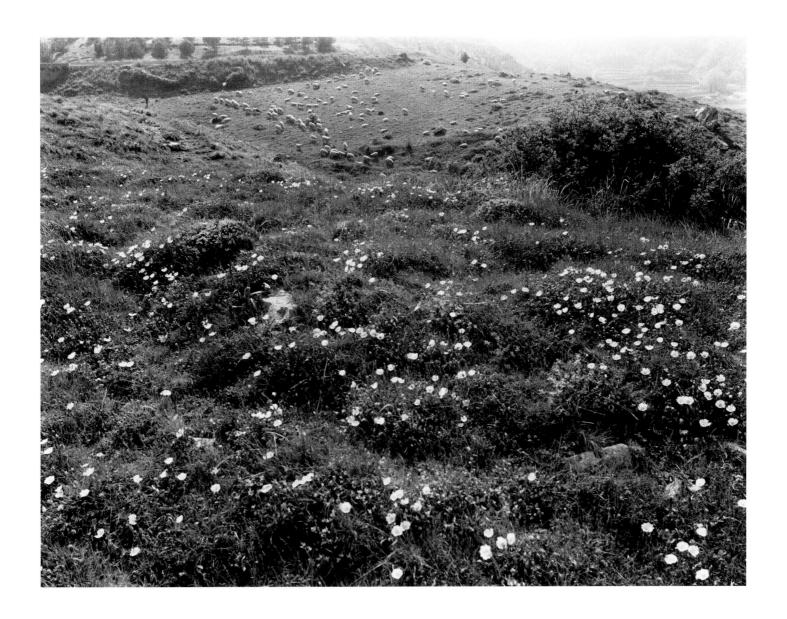

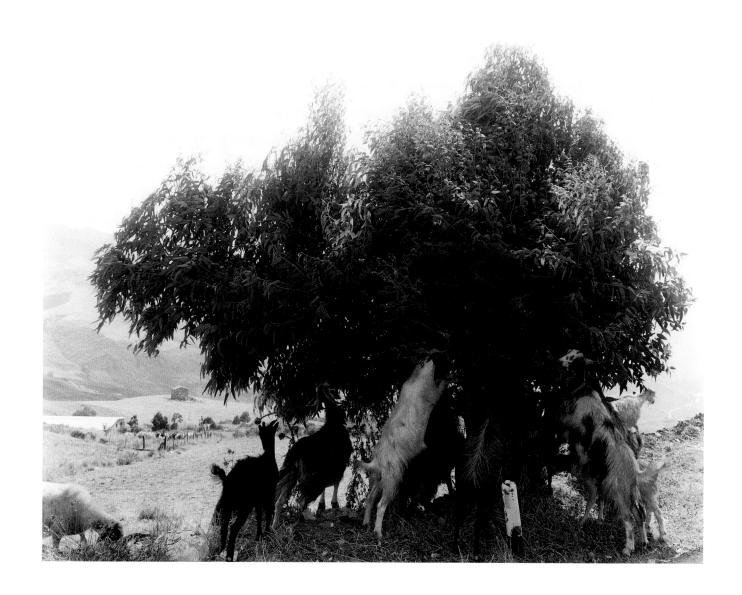

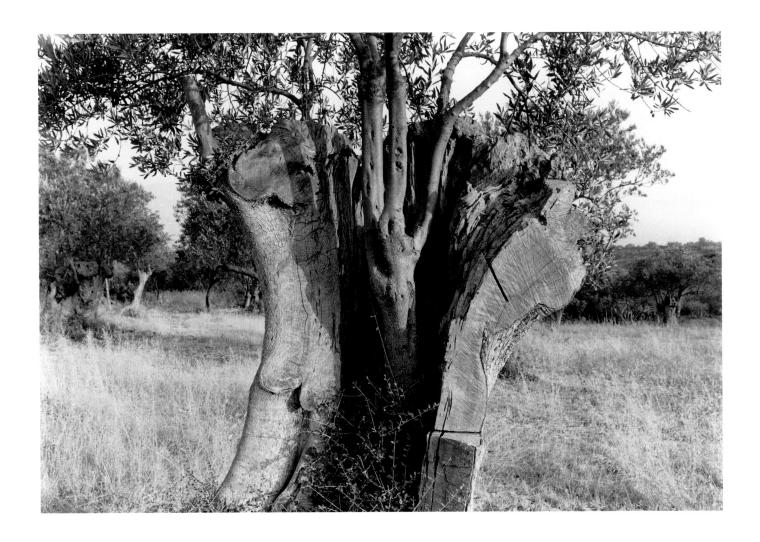

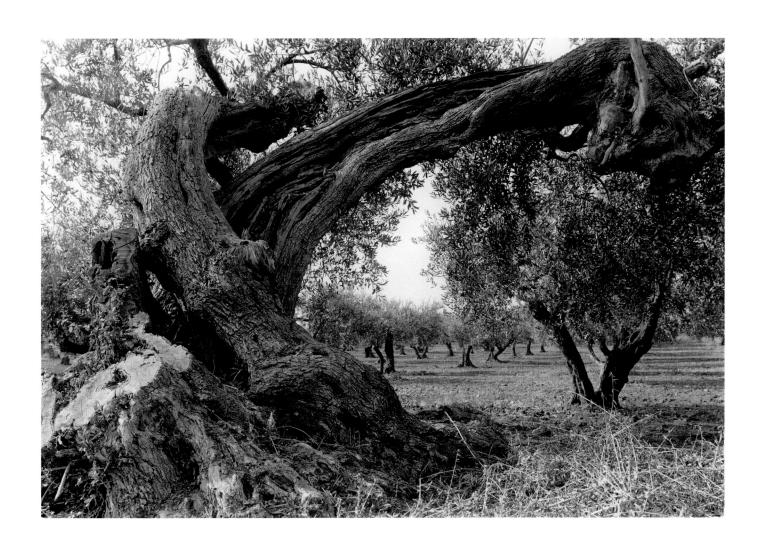

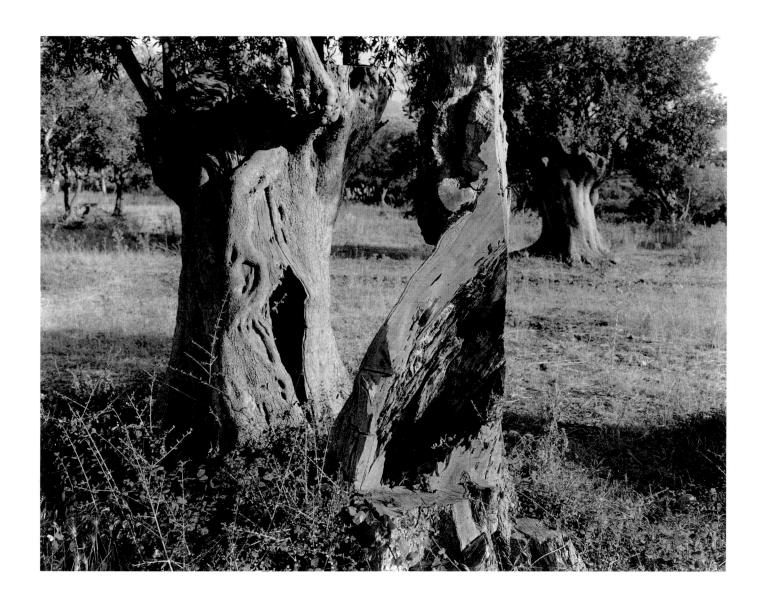

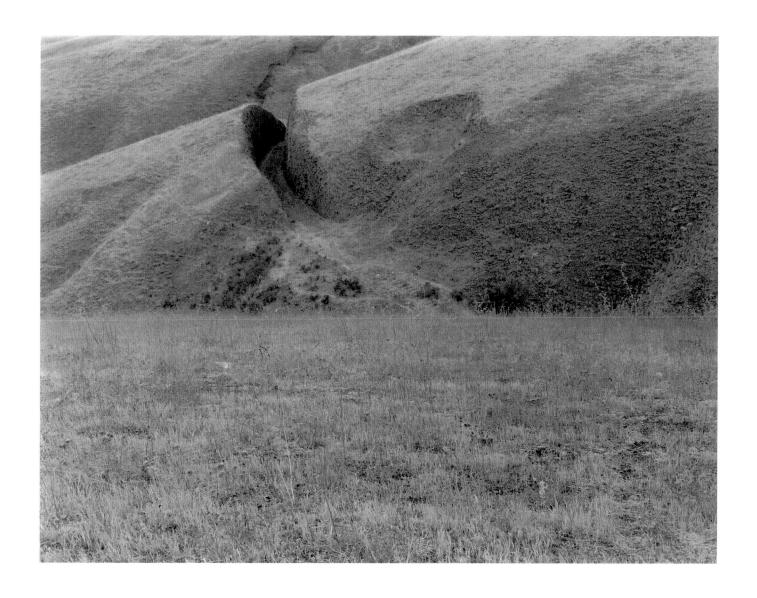

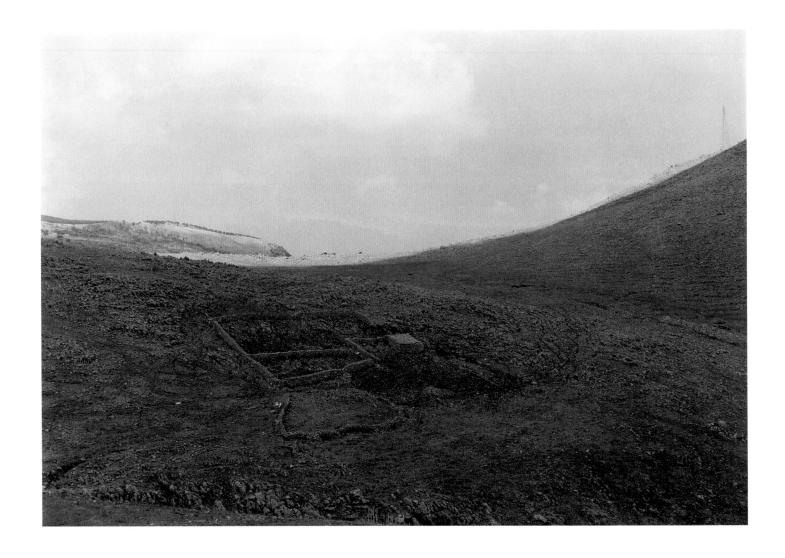

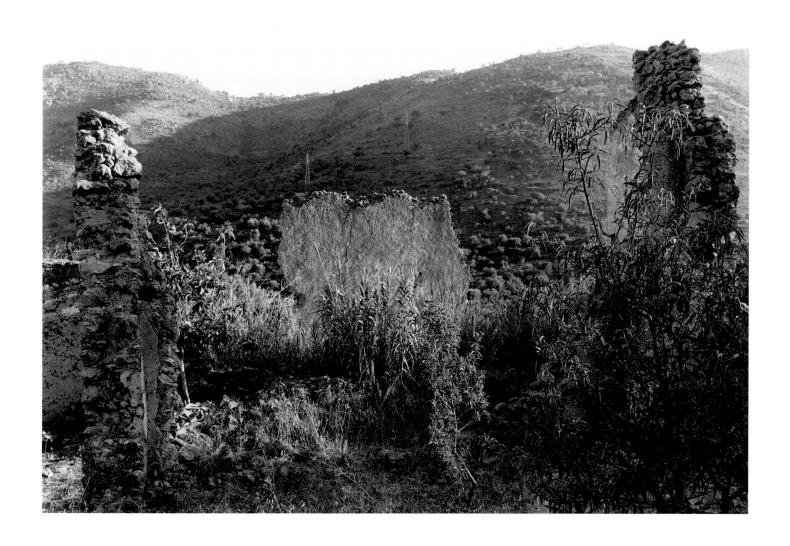

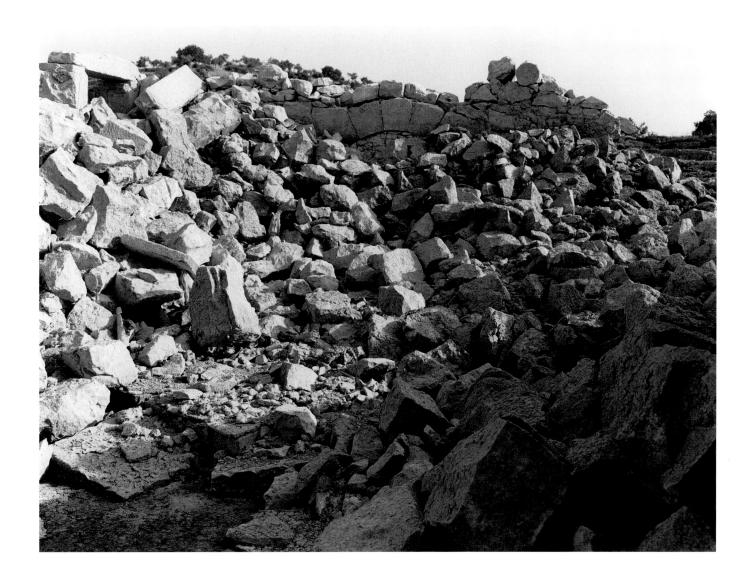

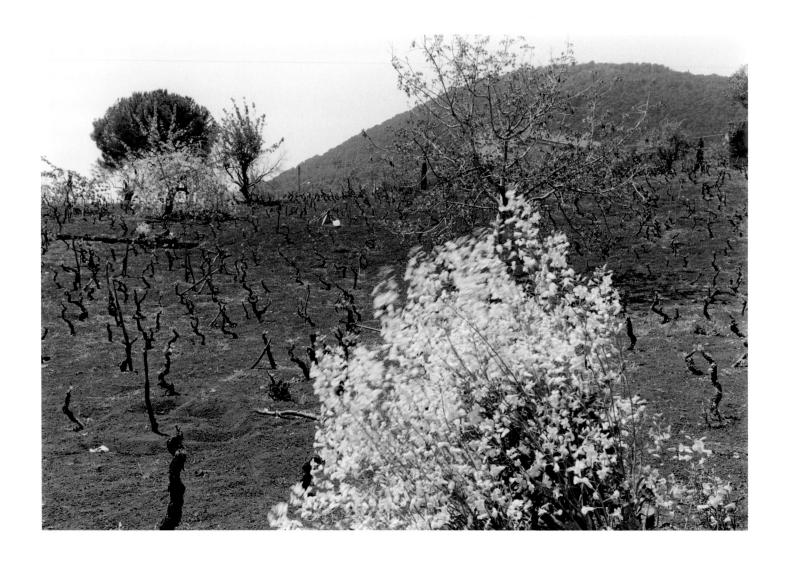

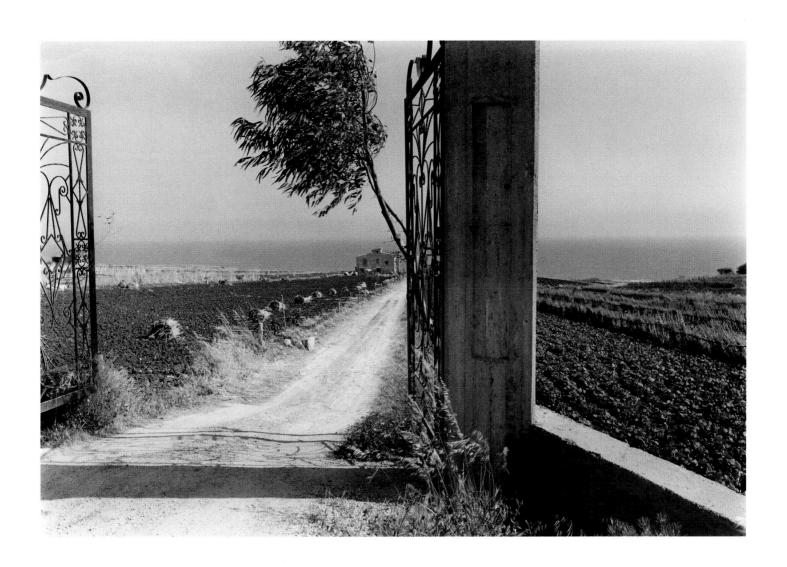

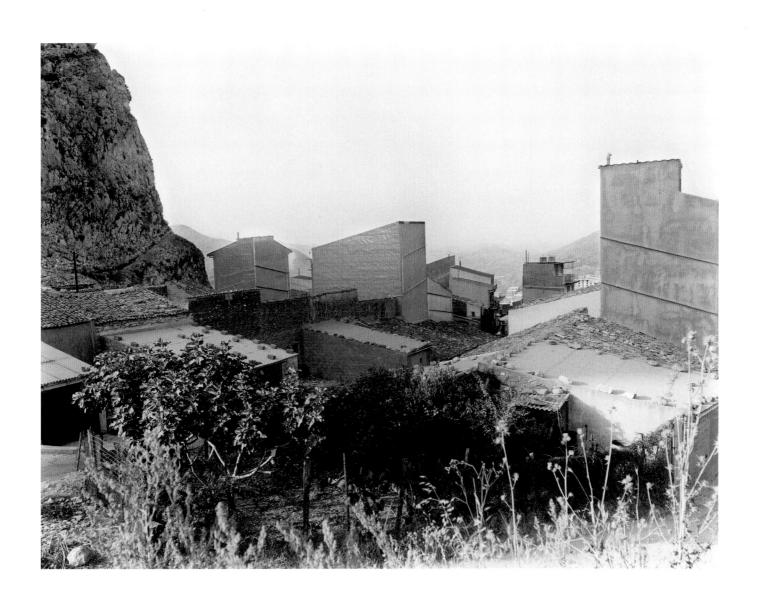

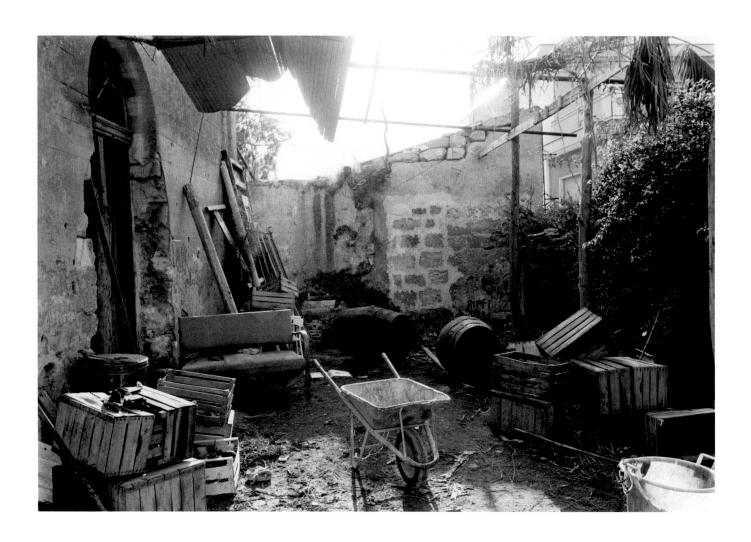

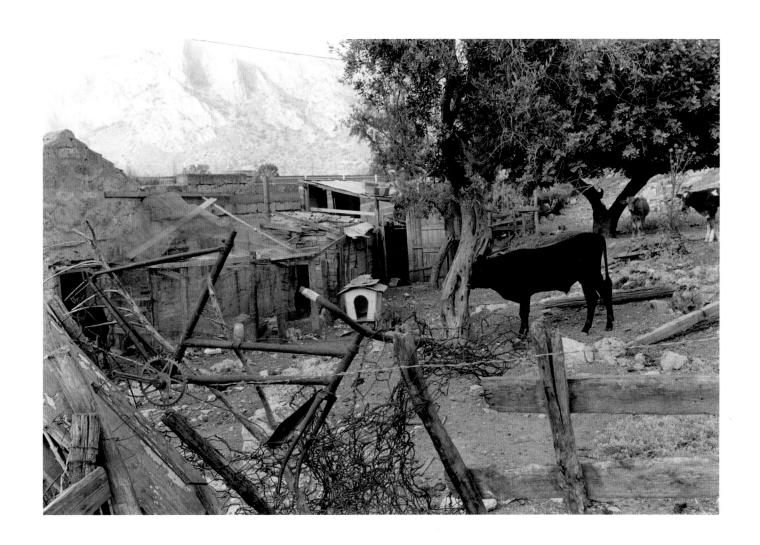

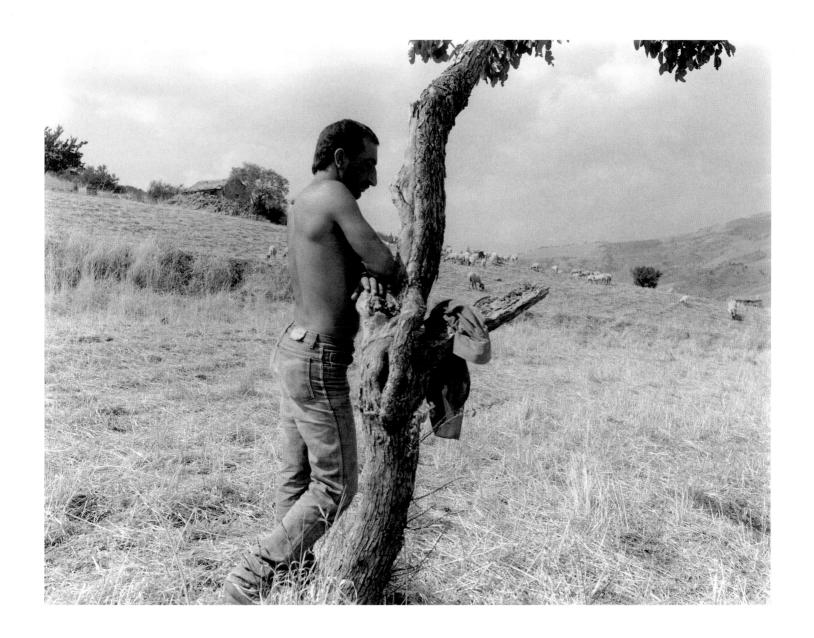

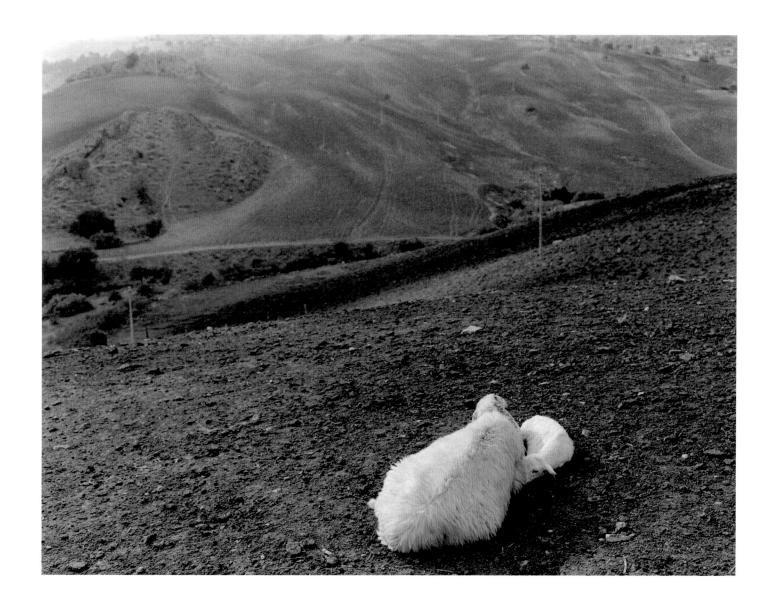

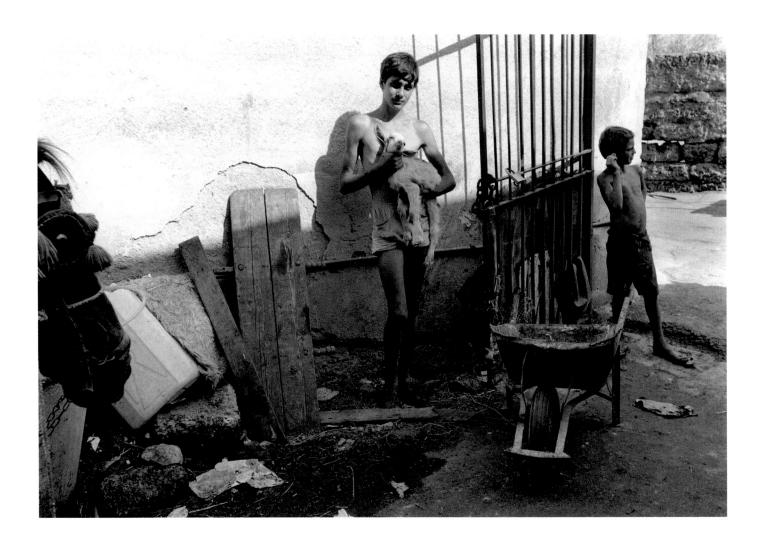

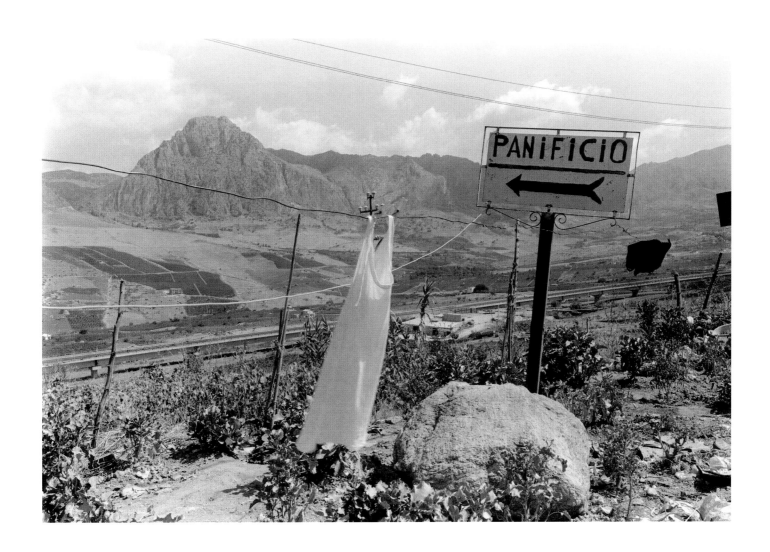

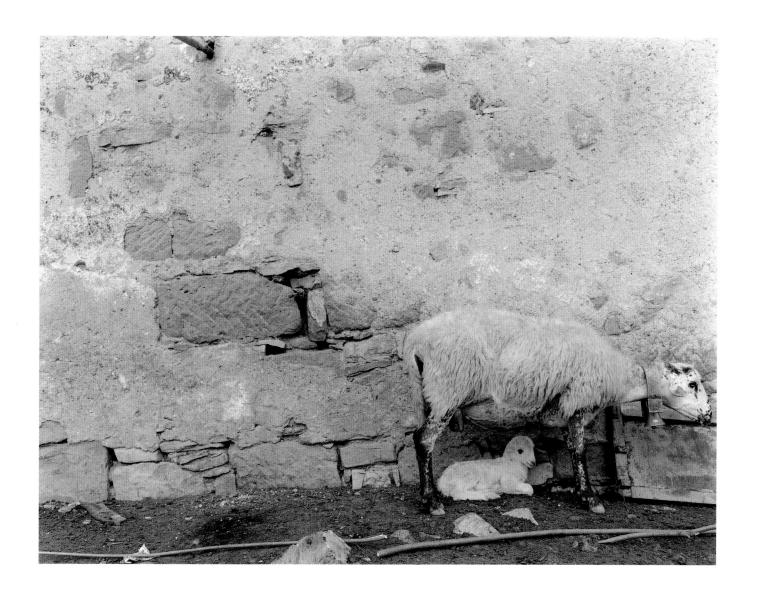

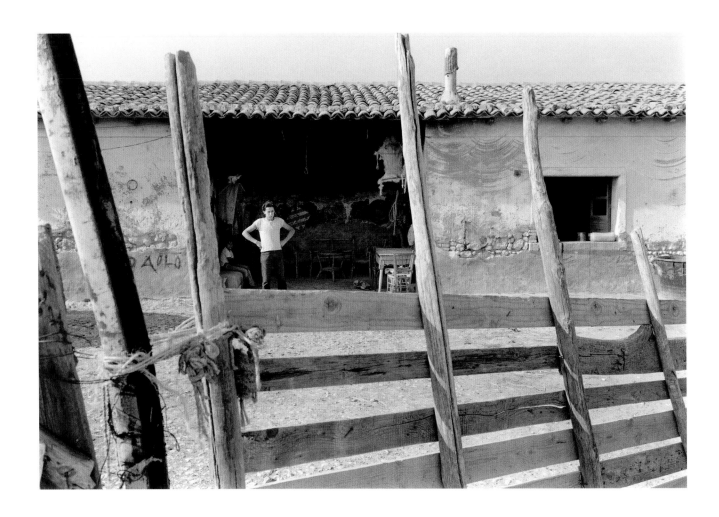

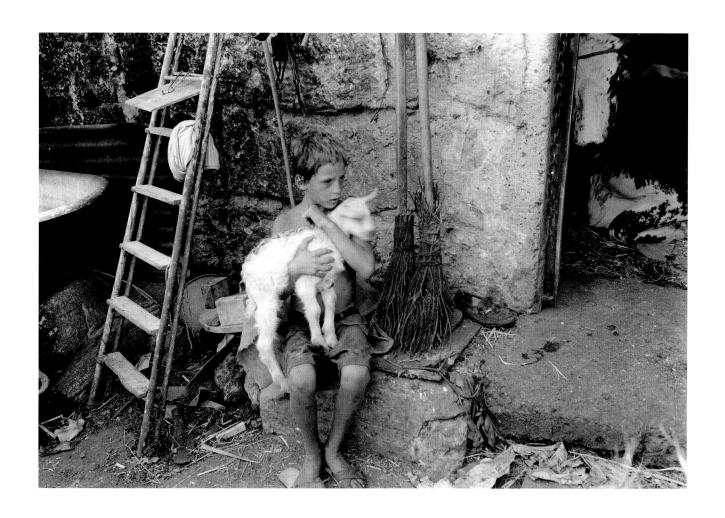

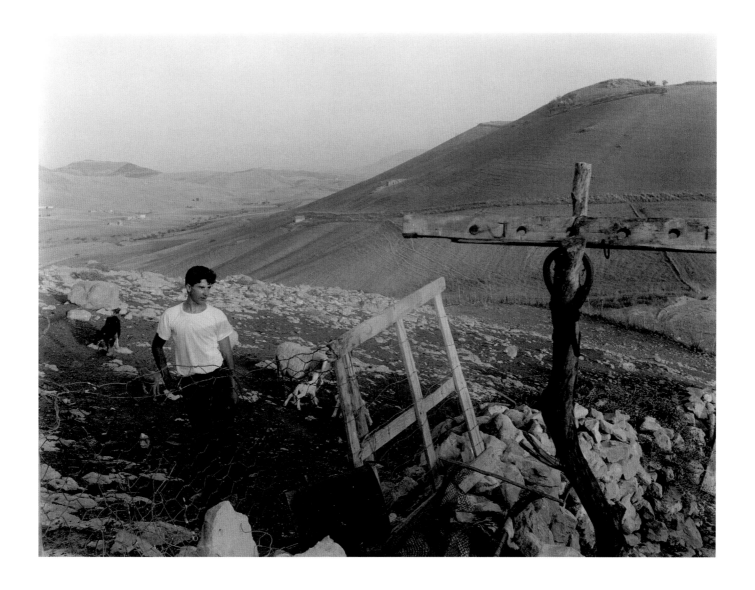

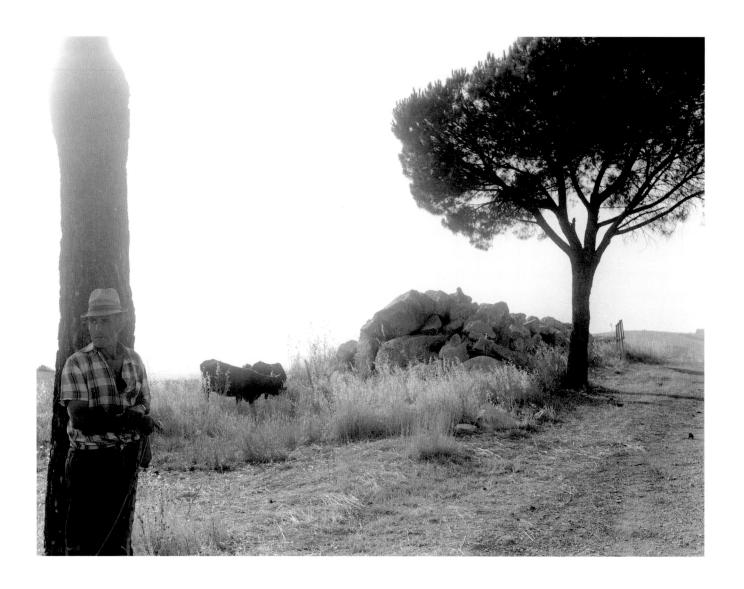

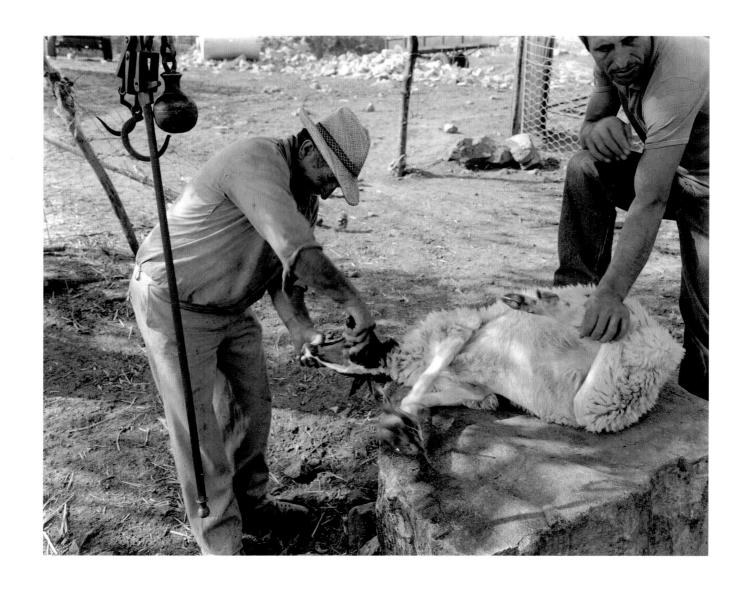

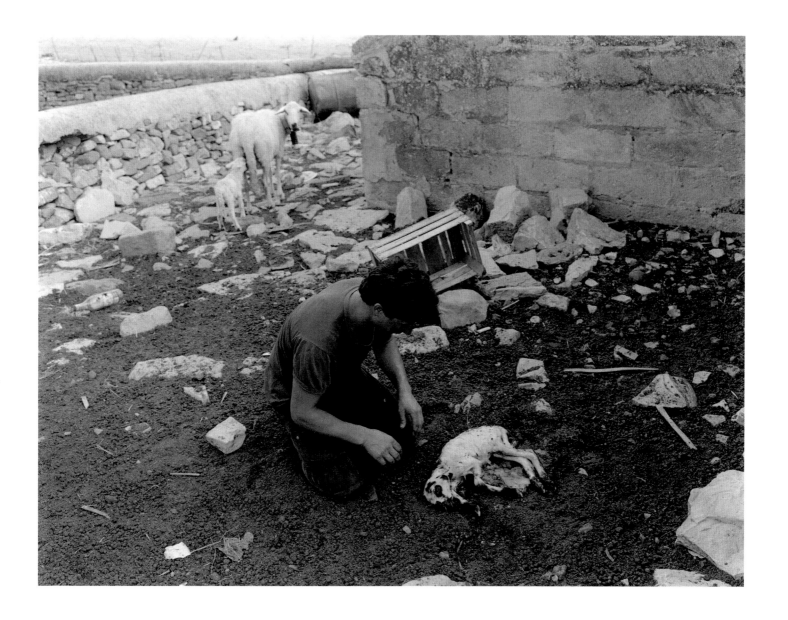

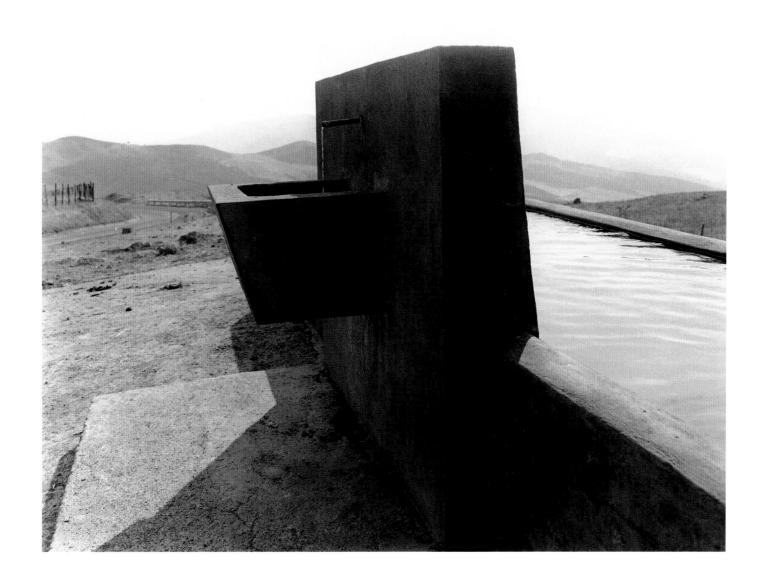

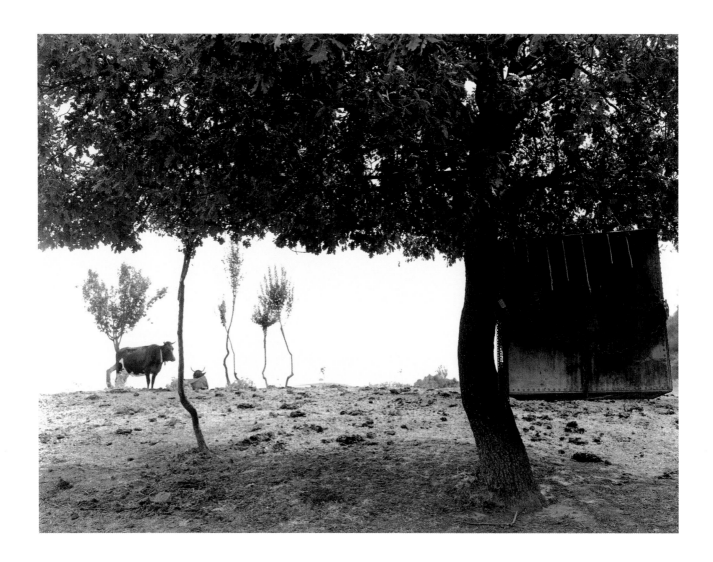

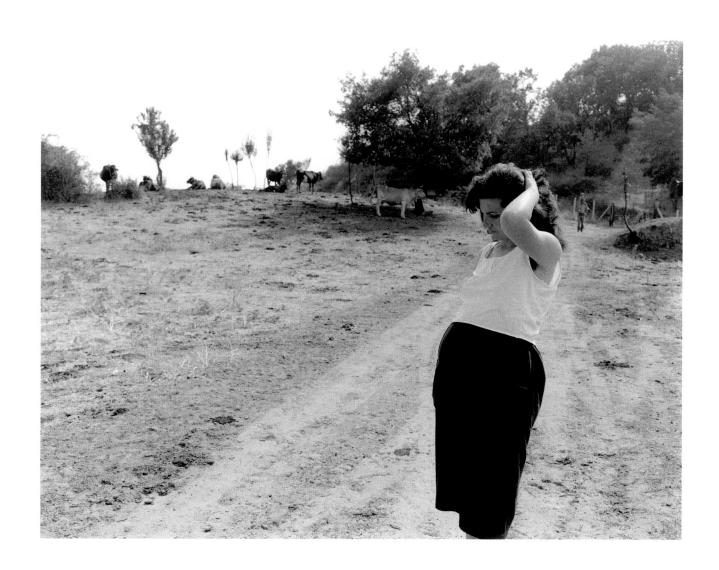

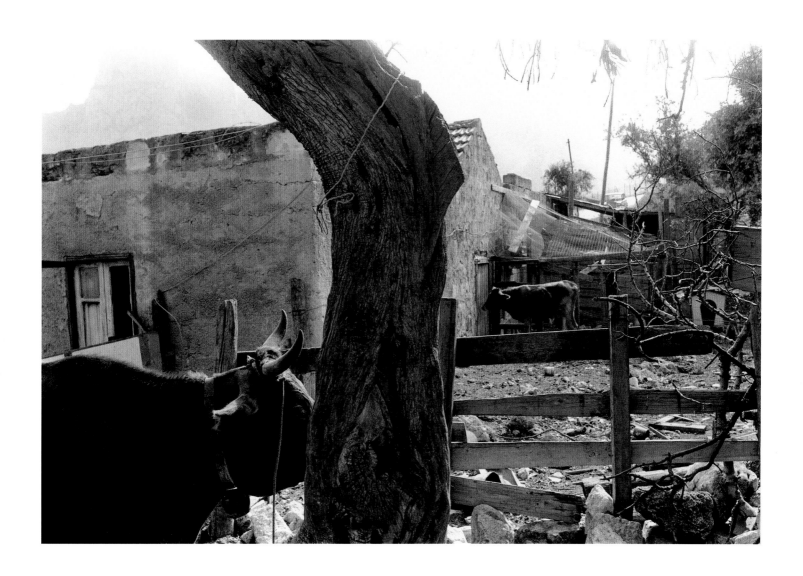

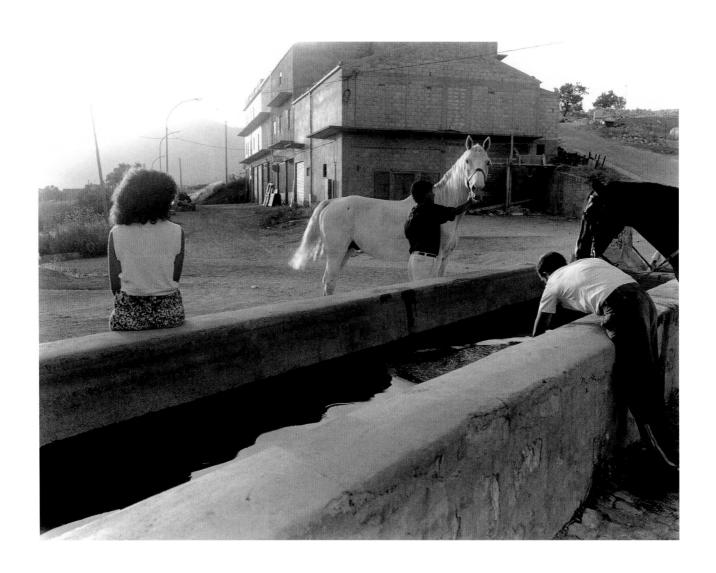

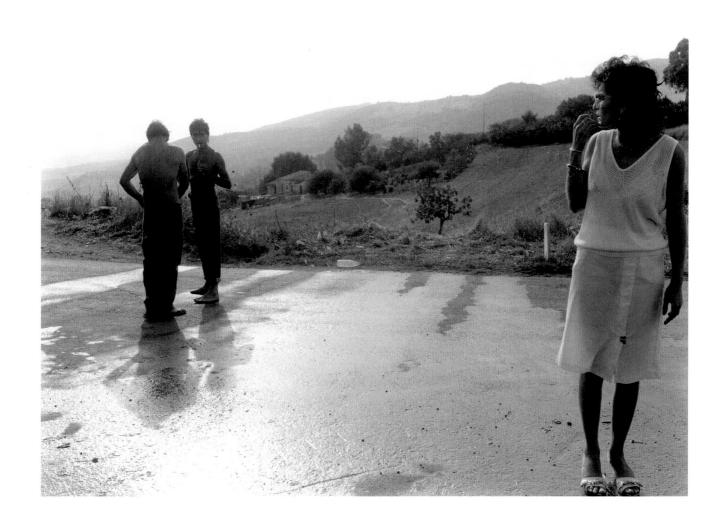

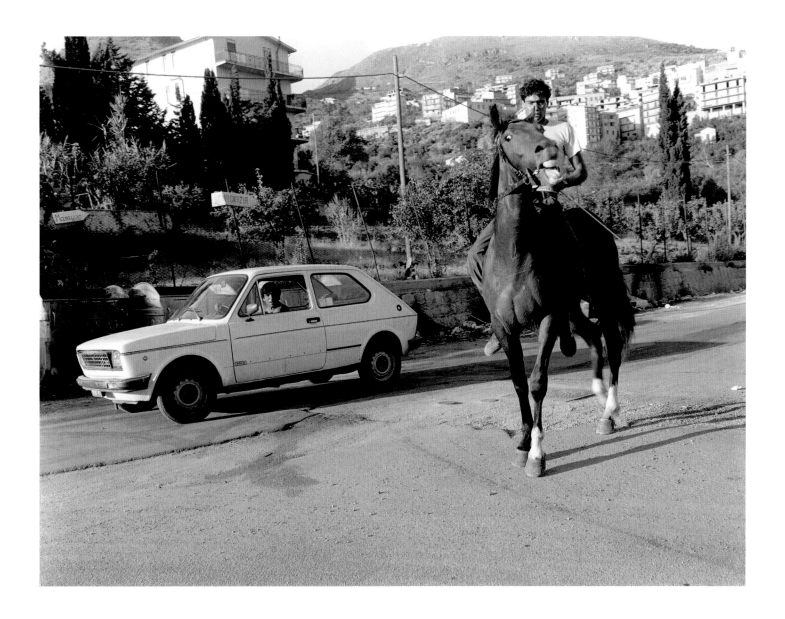

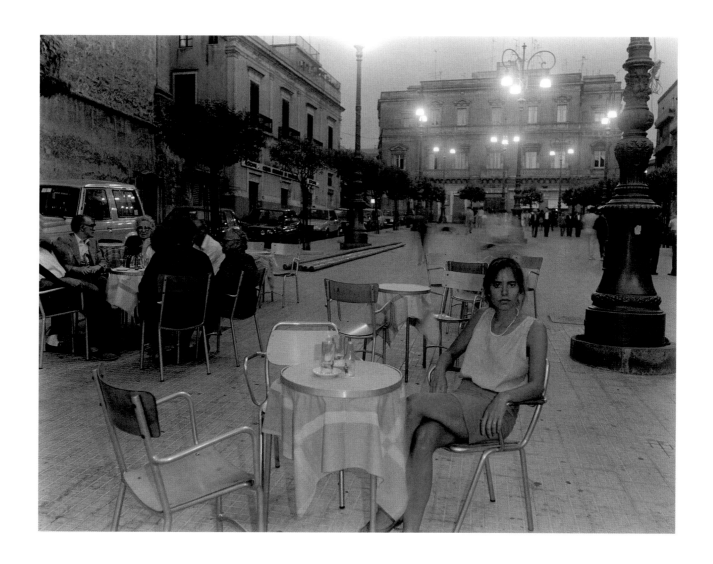

AFTERWORD BY ANNA ROMA

As TOM AND I ROUNDED A CORNER, driving the winding mountain roads almost dead center into Sicily's interior, we came upon a small cluster of buildings—something less than a farm, more a country home with cows, chickens, and gardens enough for a small family. We got out and Tom, camera in hand, spoke to the owner, a man in his mid-thirties who appeared from the back of the house at the sound of our car. As the farmer listened, reserved but attentive, Tom explained that he was a photographer from America of Sicilian descent traveling all over the island taking pictures. He began to tell the man, Antonio, all about himself, his ancestry, his work. Tom has a genuine ease when meeting people, of letting them into his life, which usually leads to an invitation into theirs. Antonio showed us around and spoke with us for some time. Later, as we were leaving, he apologized for not being able to offer us a meal—his wife was pregnant and visiting her family across the valley in Calascibetta with their young son.

When we left we knew that we wanted to come back to meet his family. A few days later we drove back all the way from Palermo. As we headed down the driveway, a woman came out of the house to greet us. She was Antonio's wife, Mariella, an attractive, powerful woman with long dark hair, who was quite noticeably eight months pregnant. She spoke more quickly and laughed more easily than her husband. Tom immediately led her off and spent more than an hour walking around their property photographing her while I kept her husband and shy son company. Later, I sat next to her in their small kitchen while she made us lunch and showed me how to soak eggplant in salted water to remove its bitterness. Mariella told me about her life, about how she left her family in the city to start a life with her husband in the country. I remember her saying that her son had been "born for her husband," and that the boy followed his father everywhere and was bound to him, and that she wondered what her second child would be like. I was drawn to her, and to her

openness and sense of purpose. I found myself asking her lots of questions—everything from how she met and fell in love with her husband to what it was like to give birth. Years later, when I was pregnant myself, I dreamt of her, and in my dream I showed her my newborn child.

*

Our first trip to Sicily together was in 1986. Tom and I had been seeing each other for only six months. I remember flying over to meet him. I flew from New York to Rome and caught a connecting plane to Palermo. For most of that hour-long flight I'd seen nothing but the dark blue of the Tyrrhenian Sea sparkling below in the noonday sun. Then, as the plane began to descend, it made a sharp banking turn and through the scratched, plastic window I caught sight of a sulfur-yellow peak rising out of the sea. A few moments later the plane turned again, putting us on a collision course for the mountain. While I'd been feeling anxious the whole trip trying to imagine what lay ahead for me on the ground, now I was suddenly consumed with the thought of just making it there safely. But before I could panic, the runway appeared beneath us on a narrow strip of land between the hills and the sea, and we landed. As soon as we touched down, the entire plane broke into applause. As we taxied towards the terminal, I began to feel the release of all the tension that had been building in me from days of wondering what it would be like for us in Sicily, a place so far from New York and so important to Tom.

We disembarked directly onto the tarmac, and I had to stop for a minute to let my eyes adjust as I looked out at the land surrounding the airport, stretching flat and desolate in the relentless sun. The airport itself was just a tower and a few low concrete buildings. I quickly passed through customs, walked into a crowded waiting room, and was surrounded by hundreds of people shouting out names, fighting to get to the front, and crying at the sight of loved

ones. I was frantically trying to find Tom's face in the crowd. When I finally saw him, smiling and comfortable in the swell of the bustling crowd, his face more tanned and his hair wavier than when I'd seen him two weeks earlier, I felt my own eyes well up with tears. As even more passengers came into the small terminal we were all pushed outside into the intense afternoon heat. Once out in the Sicilian countryside, the din of the people seemed to be swallowed up by the empty landscape, and I remember feeling as if it were a scene from a film—that the whole airport would disappear like a movie set once we were gone. Tom led me to our car, and we drove along the coastal road, with its salty smell of sea, to our hotel just outside Palermo, near the beach, where I fell into a deep sleep and didn't wake up until the next morning.

Once, on our first date, Tom told me that he had photographed only in Brooklyn and Sicily, an idea that seemed strange to me. The photographers I'd known—and I knew a lot, being the daughter of a photographer—had flown all over the world and crisscrossed the States to take pictures. A few weeks later, when Tom asked me to come with him while he photographed in Brooklyn, I was curious to see what was there and why he and his camera hardly left it. Winding through Brooklyn, he pointed out all the buildings where he'd lived, the schools he'd gone to, and the changes he'd seen over the years. He looked at everything around him—the houses and humble gardens, the aluminum siding and wrought iron fences— the things people use to express belonging to a place, as much as the place belonging to them. As we drove on he showed me where he'd bought his first car, and where, as a seven-year-old, he'd stood crying over the new cap he'd left on "The Whip," a spinning kid's ride that used to travel from block to block. His past swirled around in my head, in no particular order, as he anchored himself on these touchstones scattered all around Brooklyn.

Tom's mother's parents came to Brooklyn from Sicily in the early 1920s. His grandfather was from Palermo, his grandmother from the small mountain town of Montelepre. Tom told me that as a child he used to try to dream of Sicily as he drifted off to sleep. Lying in bed, he'd picture mountains that were higher than the Berkshires he'd seen in upstate New York, and a sea that was bluer than at the beach at Coney Island. He imagined a place where the sun was brighter and where figs grew bigger and sweeter than they did in his grandparent's backyard in Brooklyn. It was almost as if he were trying to remember someone else's memories: the exotic backdrop of his grandparent's stories and the proverbs that, often to his chagrin, were used to explain everything: "You can't go to bed a dog and wake up a cat…" He thought Sicily must be the most beautiful place on earth, and he couldn't imagine why anyone would ever leave.

The morning after I arrived in Sicily, over our breakfast of caffè latte and brioche, Tom plotted our first *giro* (literally a "turn"). He wanted to take in as much as possible, then return to Palermo and plan the rest of our trip. As I stared at the large map unfolded on the table, my mind drifted off, and I was overcome by what this trip might mean for us. The next day we set off on our six-day tour encompassing the entire island, sticking roughly to the coast, but turning into the interior from time to time.

Tom had rented a small, boxy Fiat with no air conditioning. I would push my seat back as far as it would go and ride with my feet propped up on the dashboard. We'd roll down all the windows and become engulfed by the scent of wildflowers and burning wheat fields as the hot breeze blew in. And every once in a while we'd be overcome by the even hotter sirocco winds that blew over the Mediterranean from the Sahara like a blast furnace. I'd be lulled by the view of the landscape as it glided by until the car suddenly stopped and backed up—signaling that we had sped past something that had caught Tom's eye. Sometimes a place looked interesting and he wanted to stop and get a better look, but other times it was as if he'd seen a picture whole, in an instant—the side of a wall and a distant view of a mountaintop town or a makeshift chicken coop creating a crazy still life. We stopped so often that it felt like

we spent as much time going backward as forward, and we joked that we'd return the car showing fewer miles on the odometer than when we started. After that initial grand tour, we traveled at a much slower pace, sometimes spending three or four days in one place.

Most afternoons the rocking of the car, the glare of the sun through the windshield, and wine from a long lunch would put me to sleep. I'd often wake up on the side of the road, alone, in an almost-silent landscape (broken only the sound of the wind and sometimes distant sheep bells), cradled by the heat. I'd have to squint at the horizon to find Tom. When I did, he would be far off on the side of a hill or across a field; I'd see him small and distant, with his camera in front of his face photographing a shepherd, or an olive tree, or just taking in the Sicilian countryside. On one occasion he had wandered so far up a hillside that I initially mistook him for a shepherd, thinking that the monopod he carried was a shepherd's staff, only realizing when he drew closer that it was Tom.

Once I awoke in a wide valley, dotted with stony hills beneath a sky of circling hawks. I got out to stretch and found we'd stopped at a farm. Tom was busy photographing, so I stayed behind and talked with the farmer, who appeared to be in his mid-sixties, straight and fit from years of working the land. He spoke of his animals—his cows, sheep, and goats—and which ones had had trouble giving birth, which ones liked to stay out in the fields the longest, and which ones he favored with peaches. Although I speak Italian, I had to struggle to understand his Sicilian, but was mesmerized by the rhythm of the ancient dialect he spoke.

<p style="text-align:center">✴</p>

The following year Tom and I were married. Being in Sicily was an essential part of our life together, and we returned each summer until the birth of our son Giancarlo in 1991. We tried to see as much of Sicily as we could. Day after day we'd make our way down hot roads, through groves of blood orange and olive trees, oak forests and mountain passes, and along coastlines, past ancient ruins and villages made from volcanic rock, meeting people and being swept away by it all. I became the navigator, guiding us across the island, charting the course, planning where we'd stop at midday and where we'd end up by nightfall. I'd find new routes and check off roads until there were few we hadn't traveled. Tom made the pictures and I read the maps until they got so tattered that entire towns and cities disappeared into the worn-out folds.

Anna Roma · Brooklyn, New York

MY THANKS TO: The John Simon Guggenheim Memorial Foundation, Letizia Battaglia,

Richard Benson, Craig Cohen, Audrey Frank-Anastasi, Jonathan Galassi, Peter Galassi,

Alex Harris, Marvin Hoshino, Carole Kismaric, Susan Kismaric, Joseph Koudelka, Jenny

Olsson, Sandra S. Phillips, Daniel Power, John Robinson, Anna Roma, Giancarlo T. Roma,

Margaret Sartor, Carl Spinella, Gerhard Steidl, John Szarkowski, Franco Zecchin. — T. R.

SICILIAN PASSAGE

—

Published in the United States by powerHouse Books, a division of powerHouse Cultural Entertainment, Inc.

180 Varick Street, Suite 1302, New York, NY 10014-4606

telephone 212 604 9074 · fax 212 366 5247 · e-mail: sicily@powerHouseBooks.com · web site: www.powerHouseBooks.com

—

First edition, 2003

Library of Congress Cataloging-in-Publication Data:

Roma, Thomas.
 Sicilian passage / photographs by Thomas Roma ; introduction by Sandra S. Phillips ;
afterword by Anna Roma. — 1st ed.
 p. cm.
 ISBN 1-57687-164-9
 1. Travel Photography—Italy—Sicily. 2. Sicily (Italy)—Pictorial Works. 3. Roma,
Thomas. I. Title
TR790 . R65 2003
779'.945'8—dc21 2002193012

—

Hardcover ISBN 1-57687-164-9

—

Design by Marvin Hoshino
Duotone separations by Gist, West Haven, Connecticut
Printing and binding by Steidl, Göttingen, Germany

—

A complete catalog of powerHouse Books and Limited Editions is available
upon request; please call, write, or visit our our web site.

—

2 4 6 8 10 9 7 5 3 1